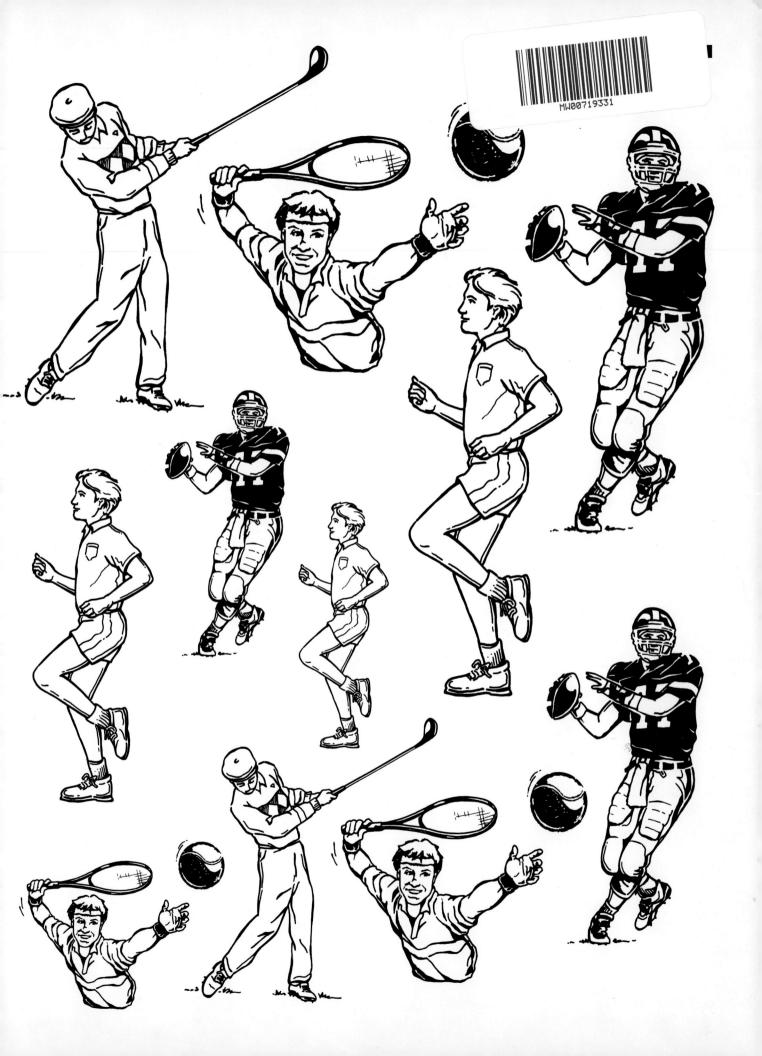

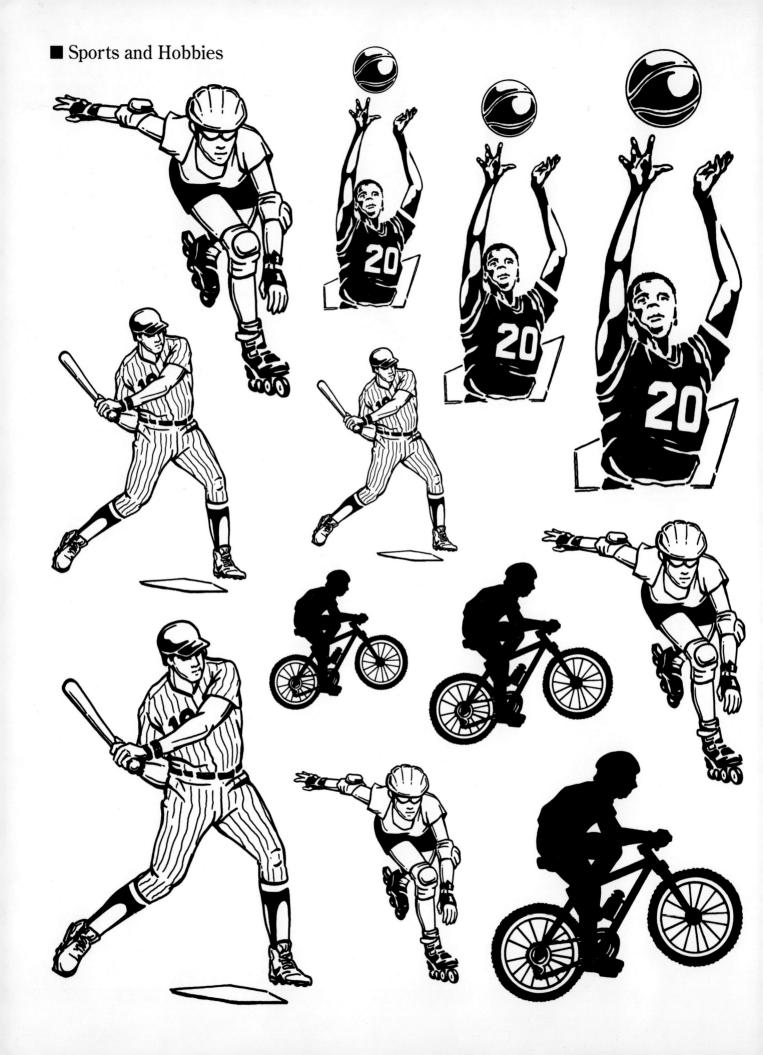

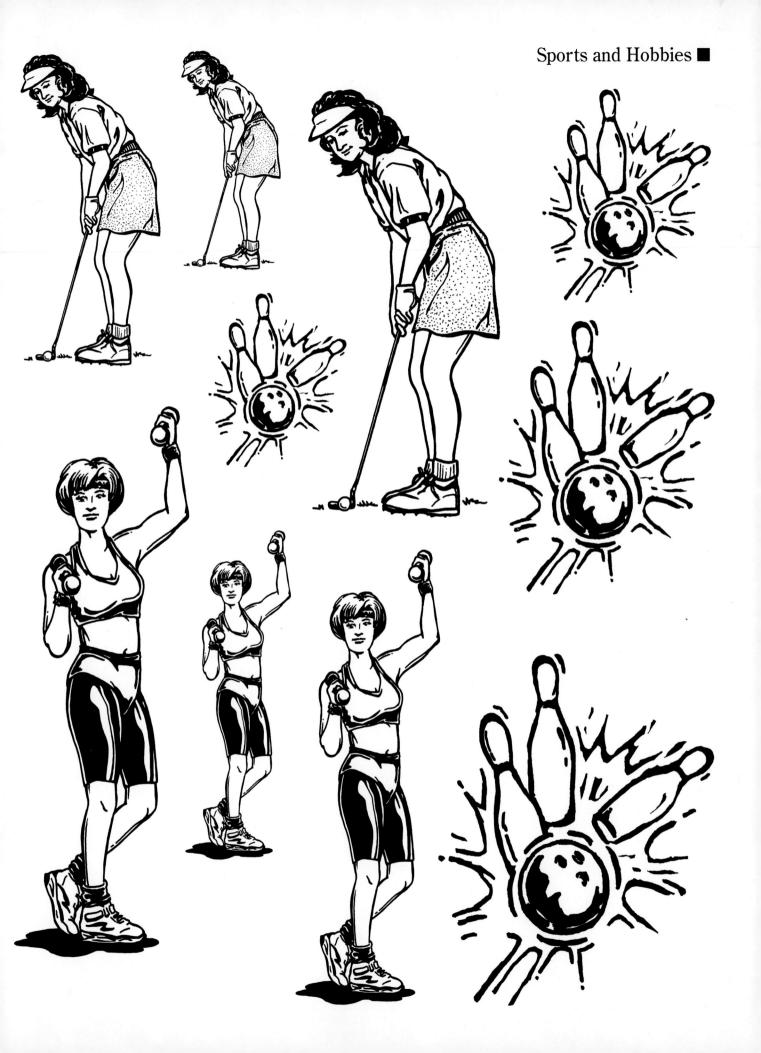

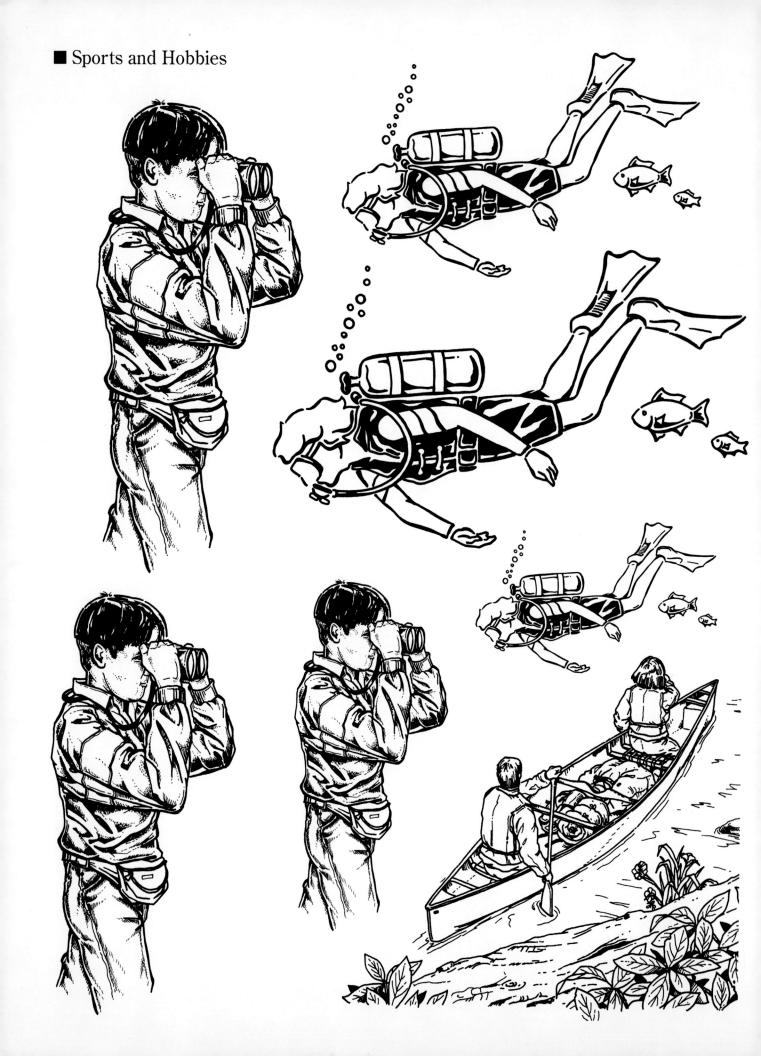

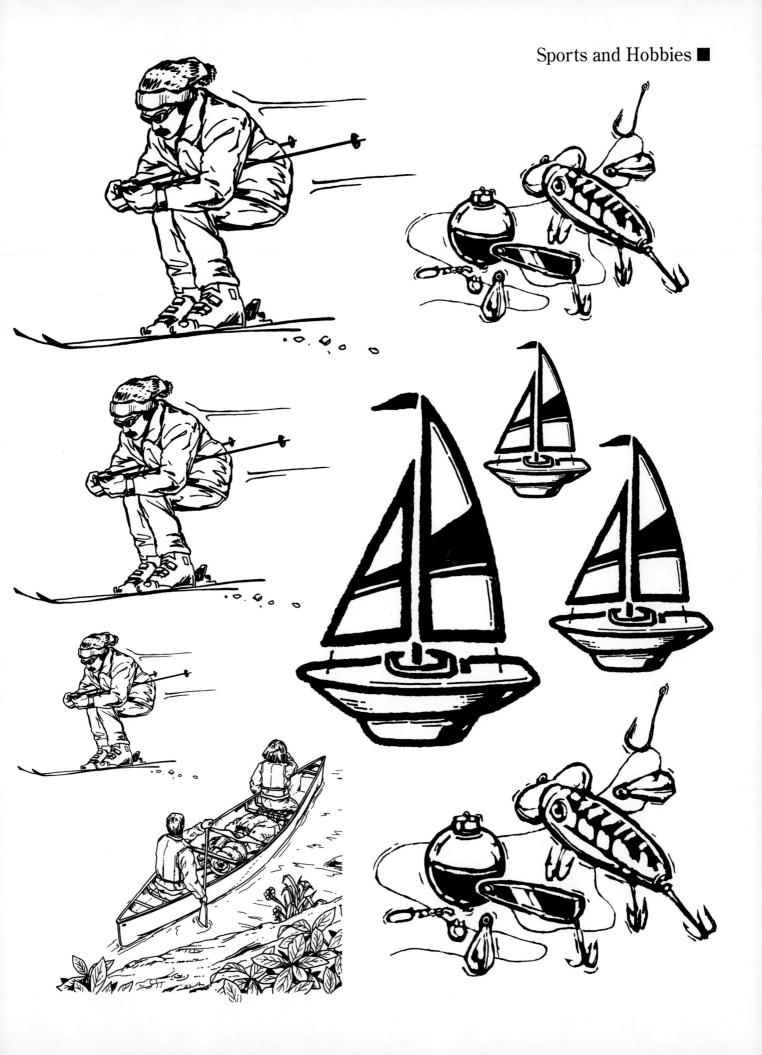

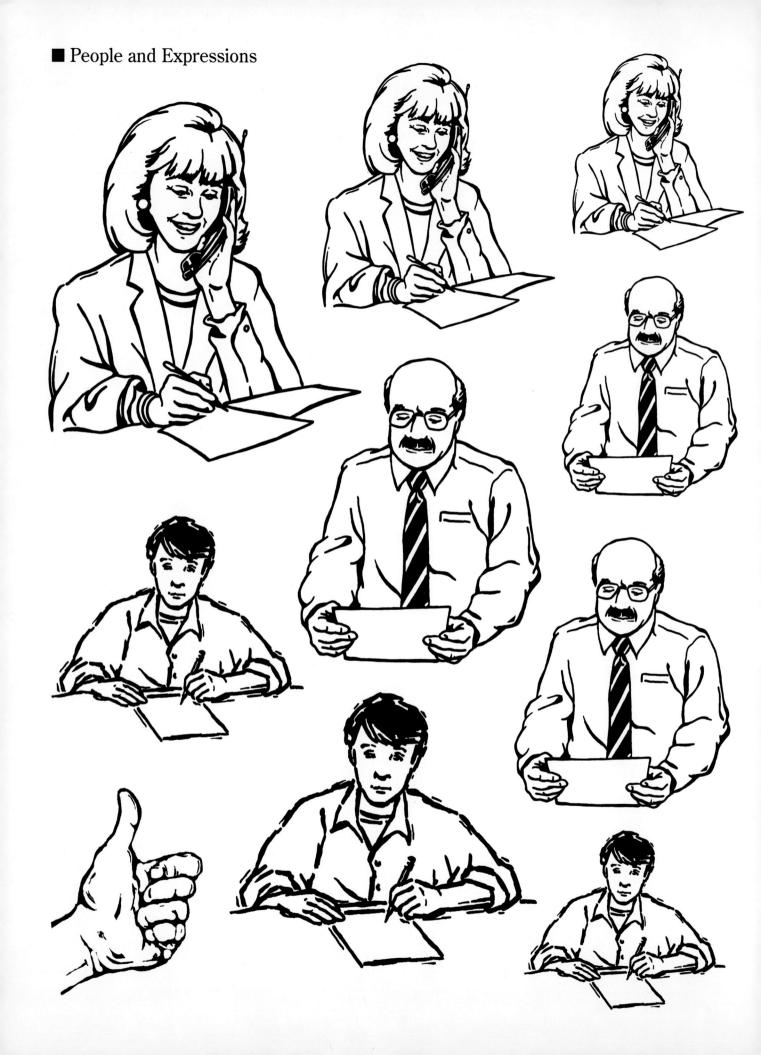

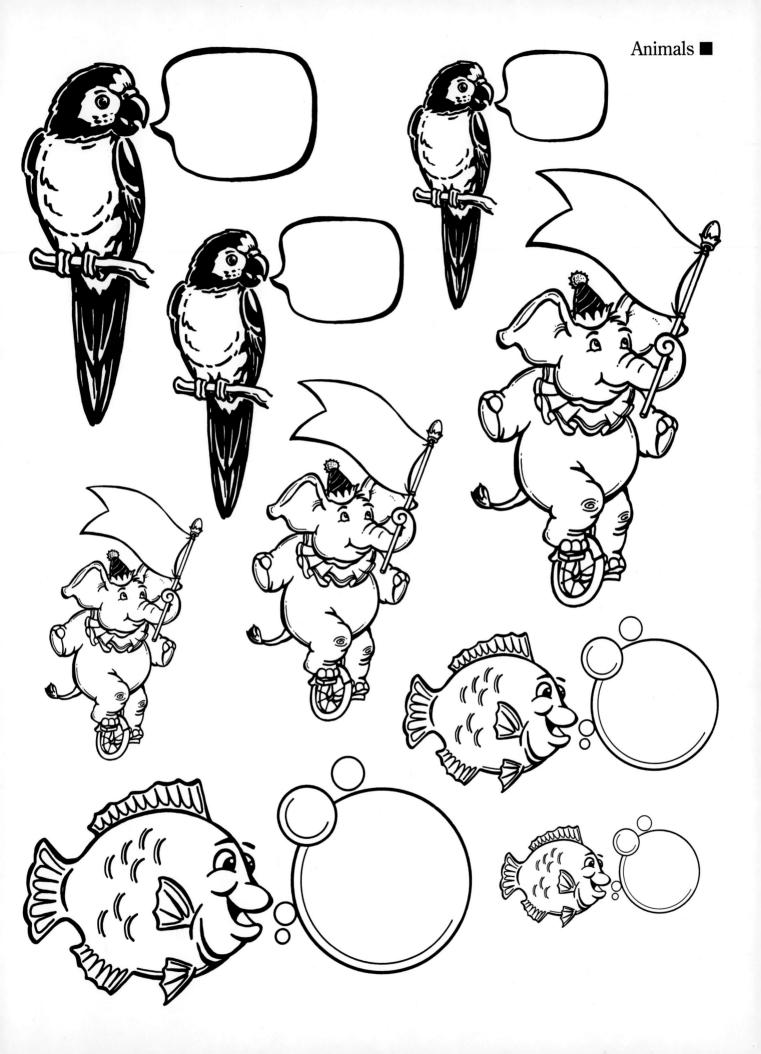

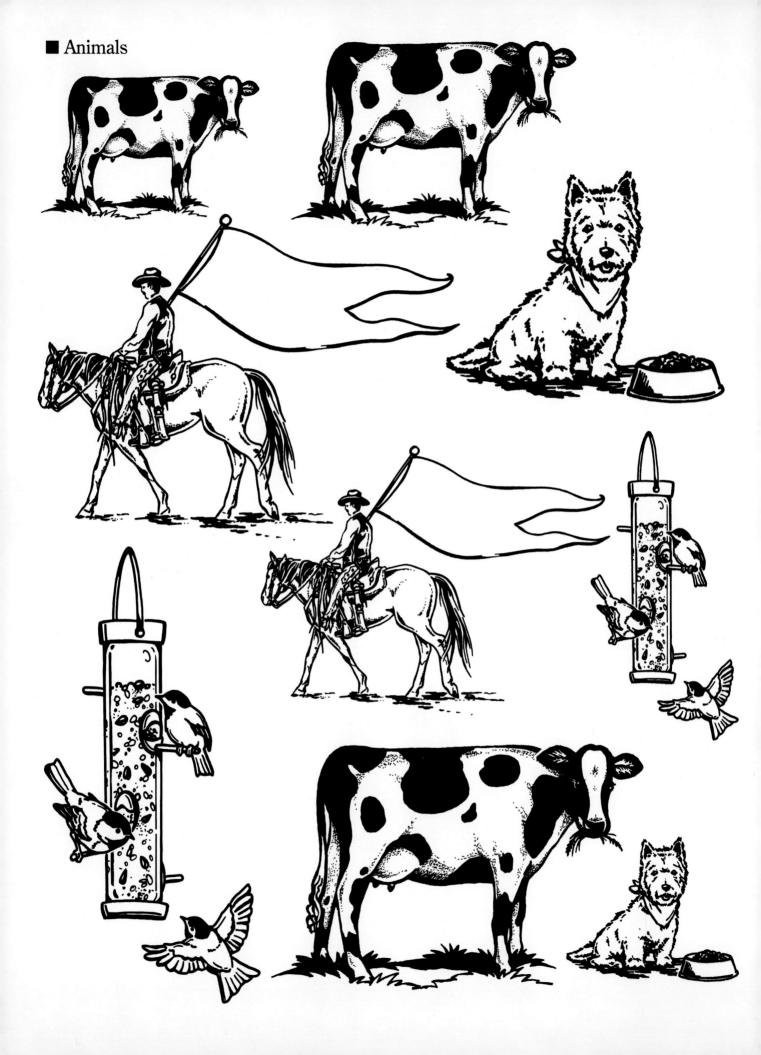

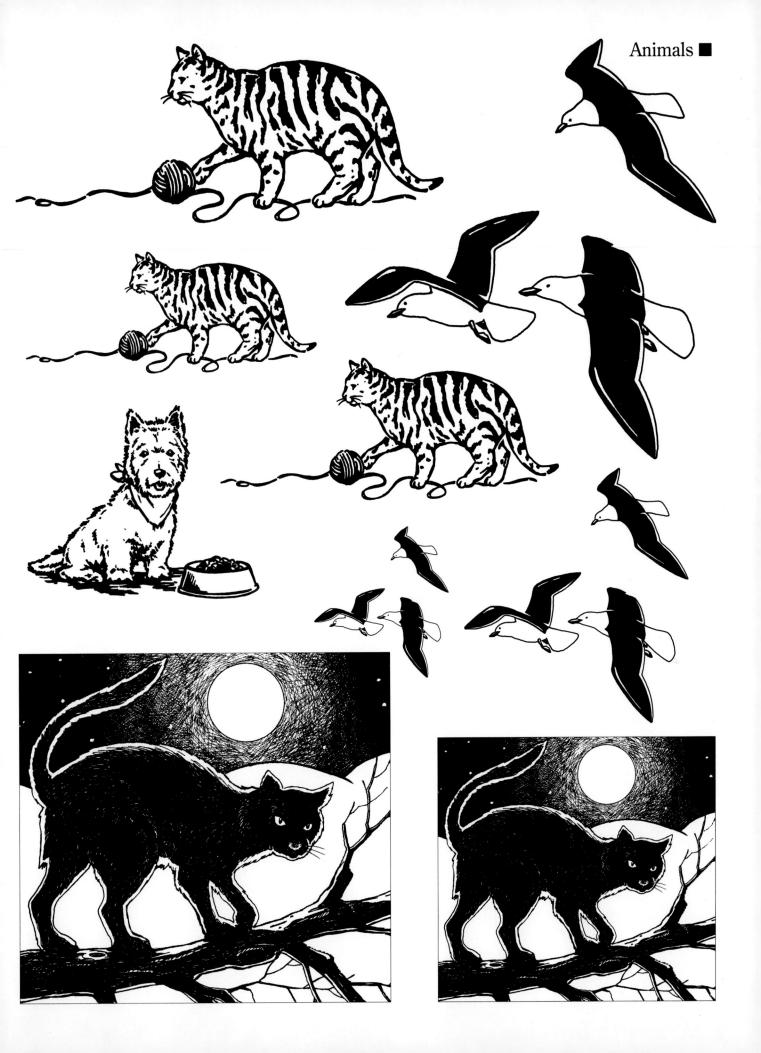

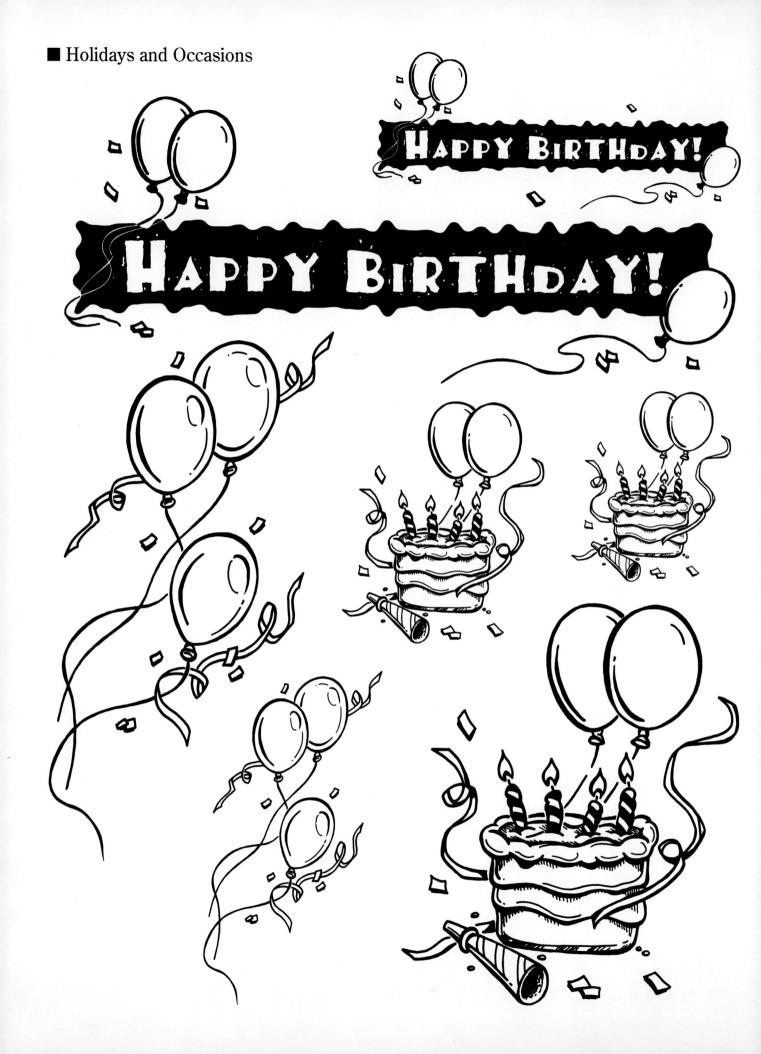

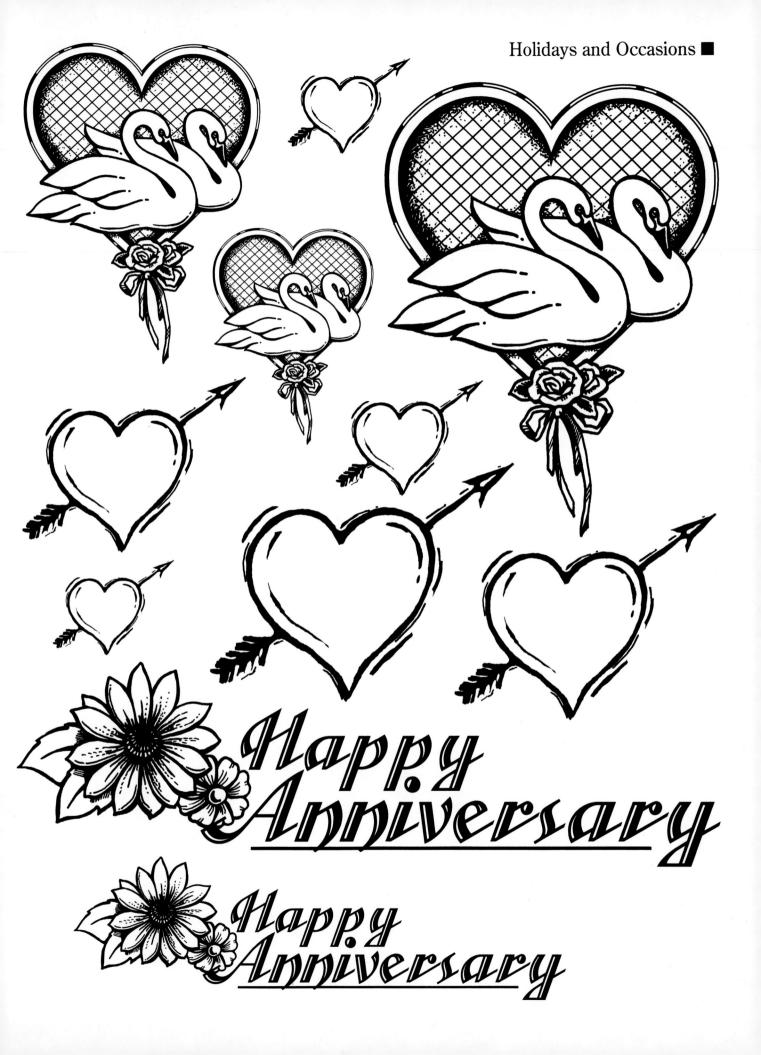

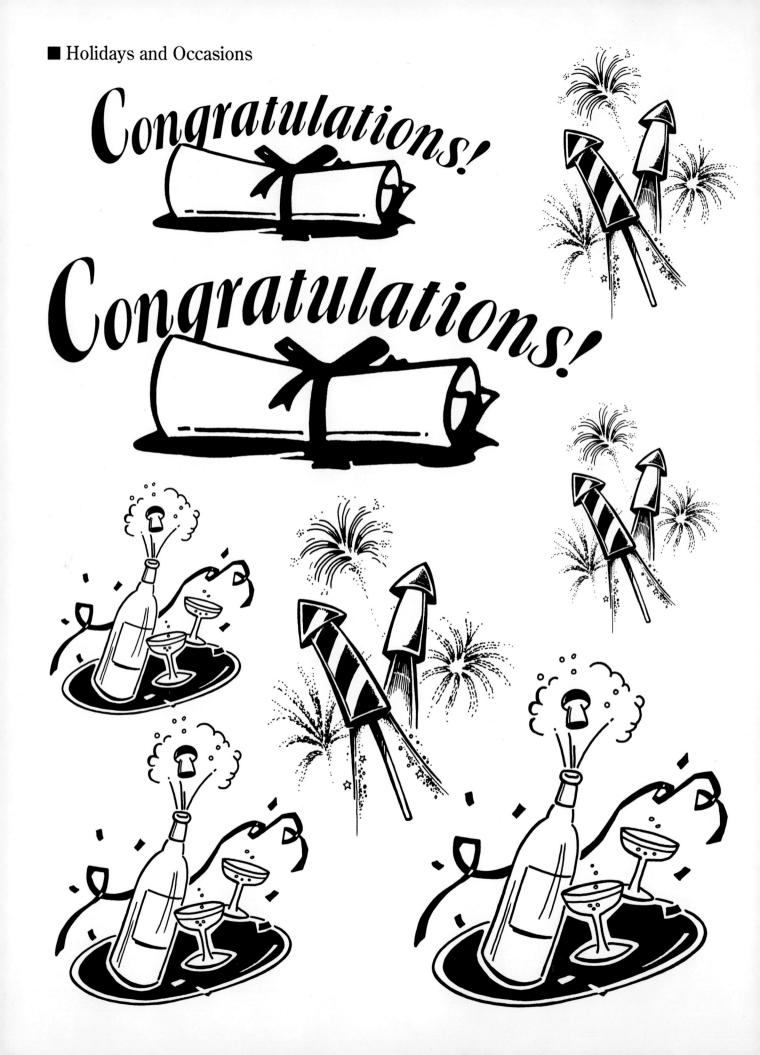

Holidays and Occasions ■

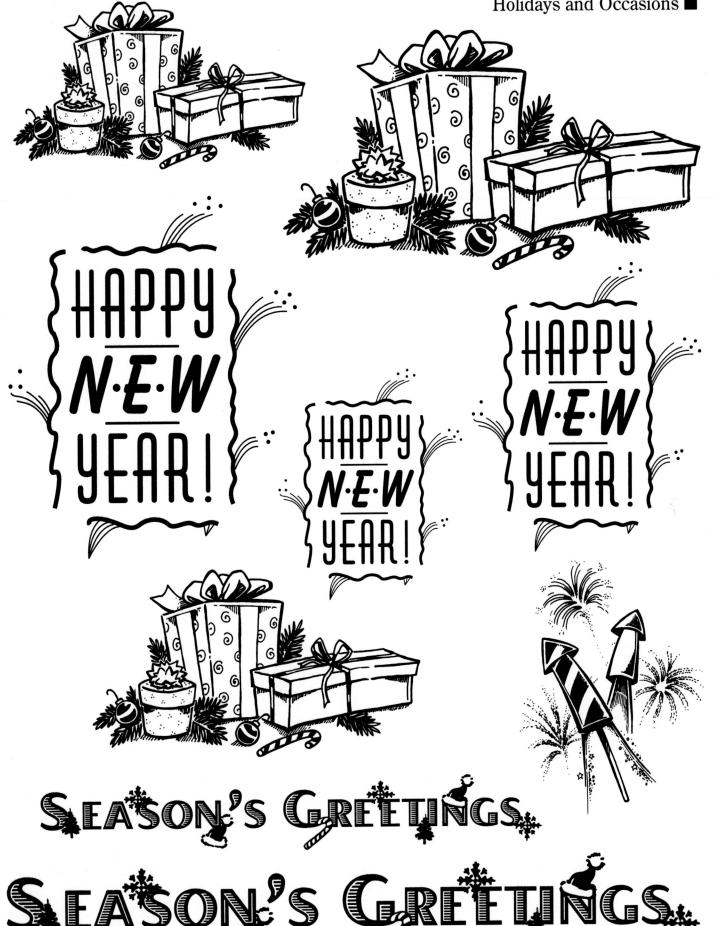

the entire south that seems to be the

REDMITIMED EMOEANE

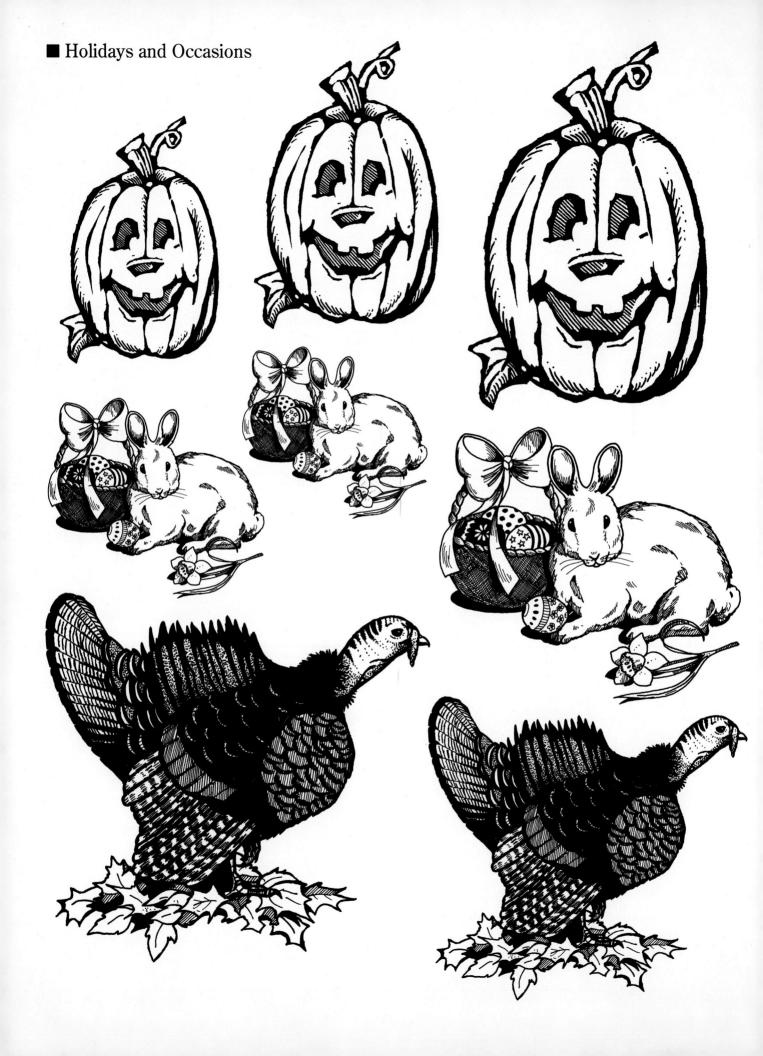

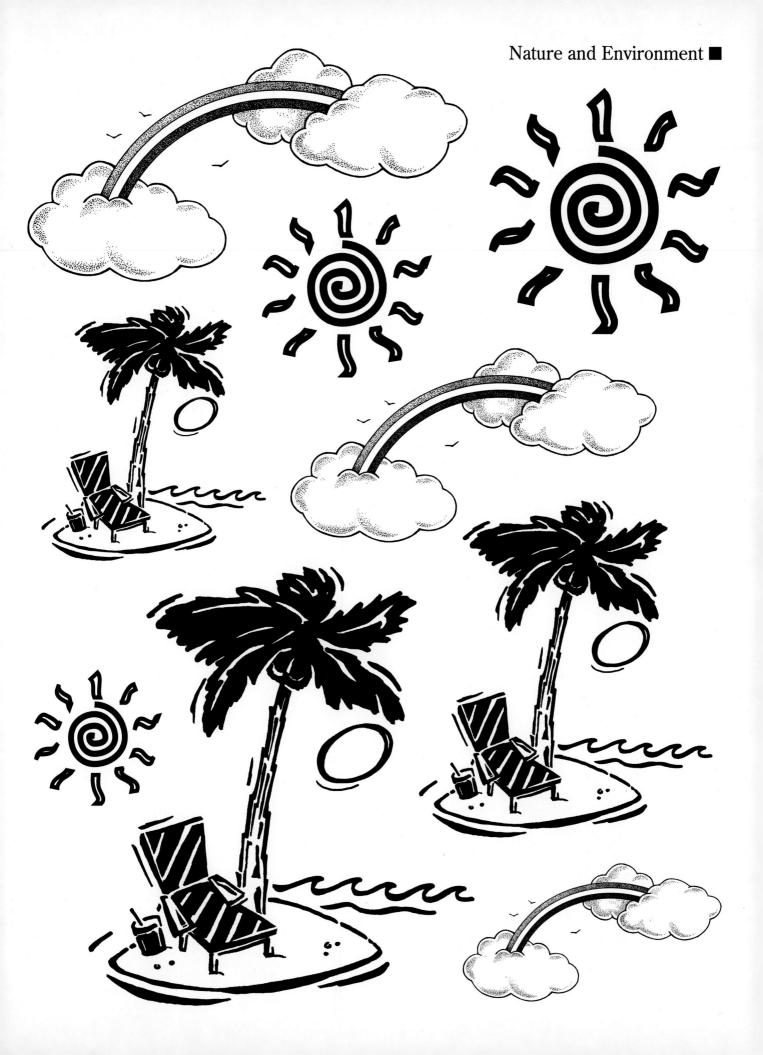

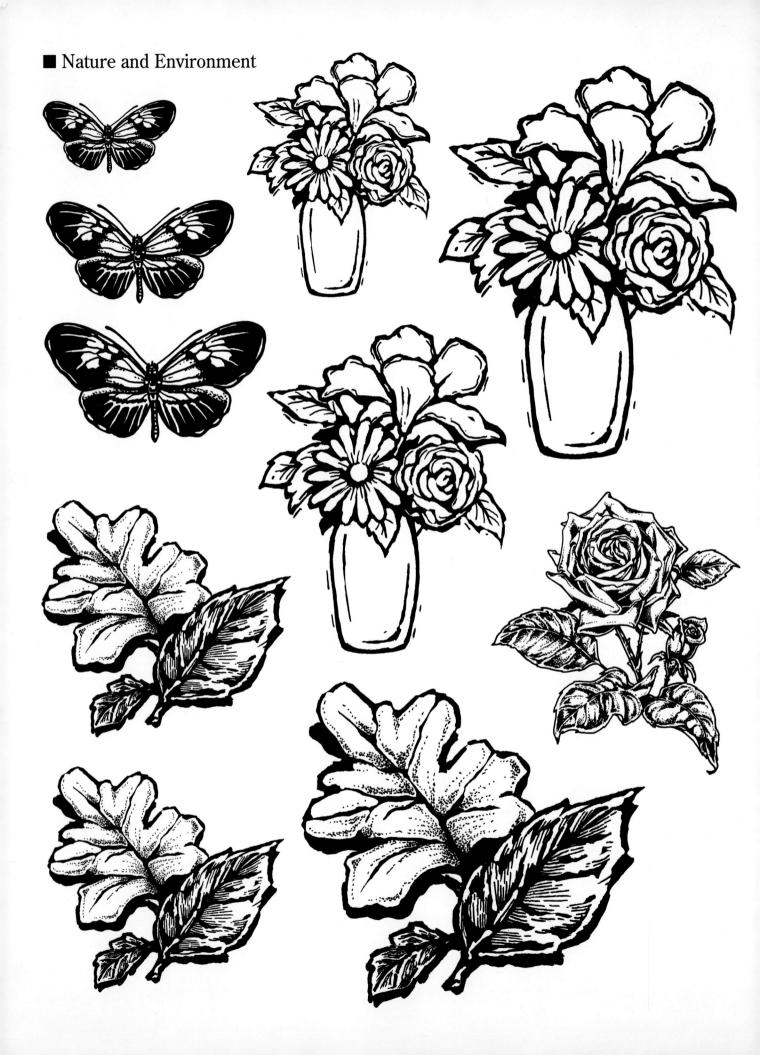

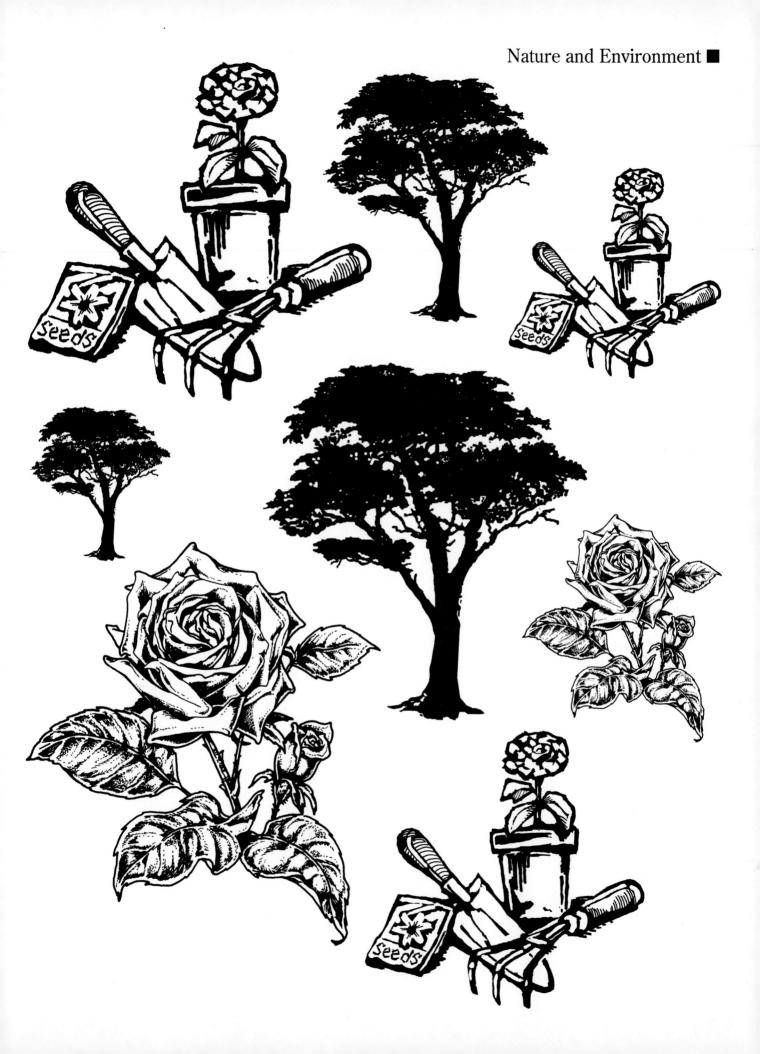

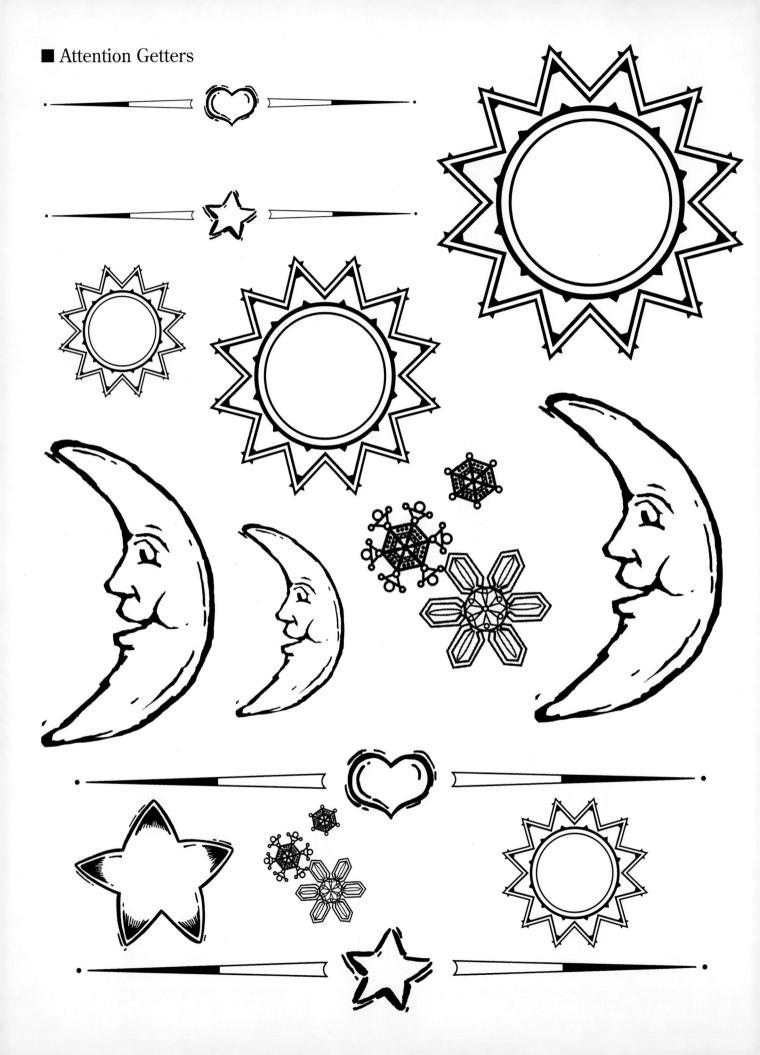

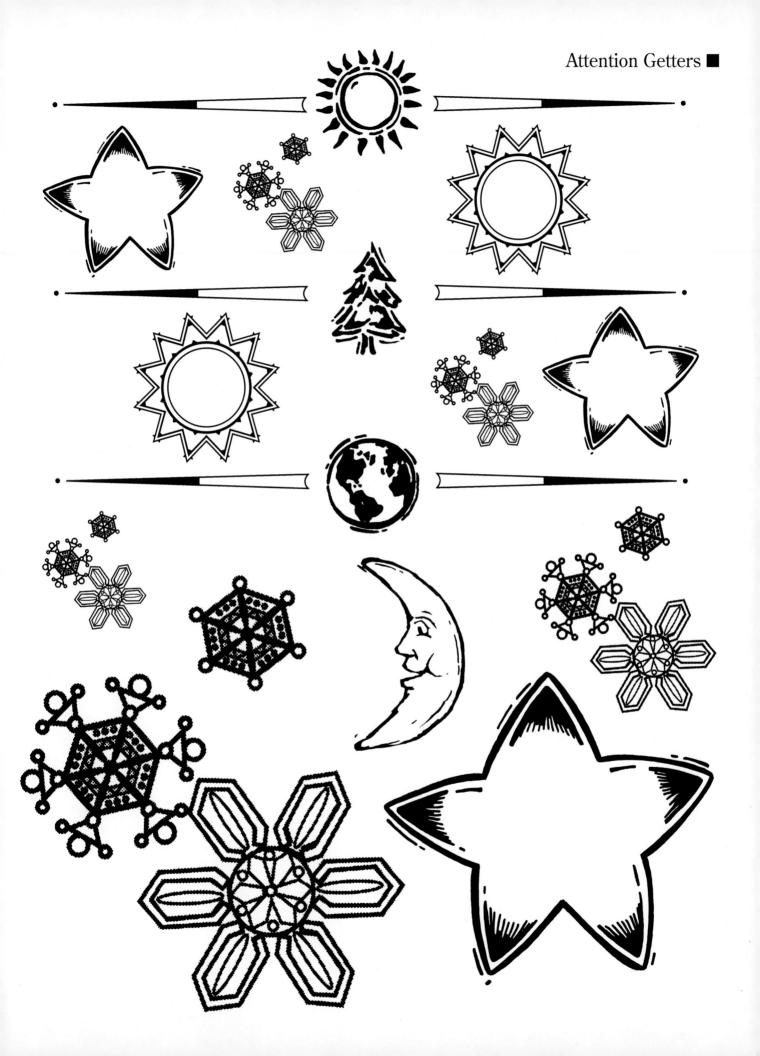

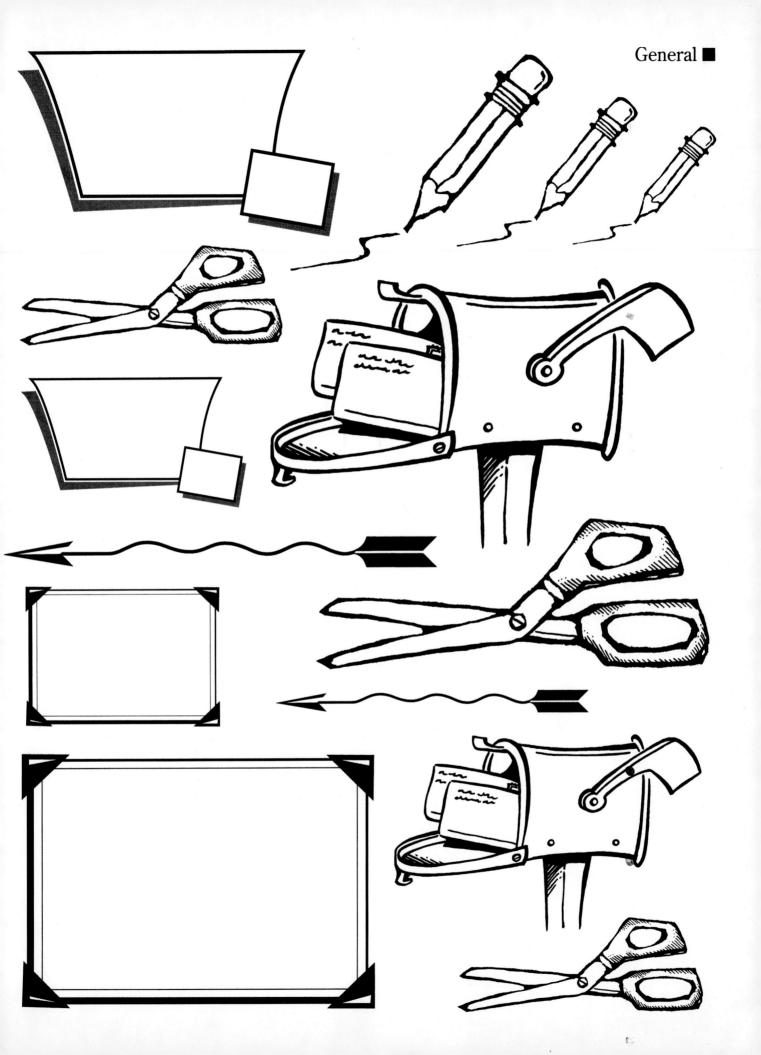

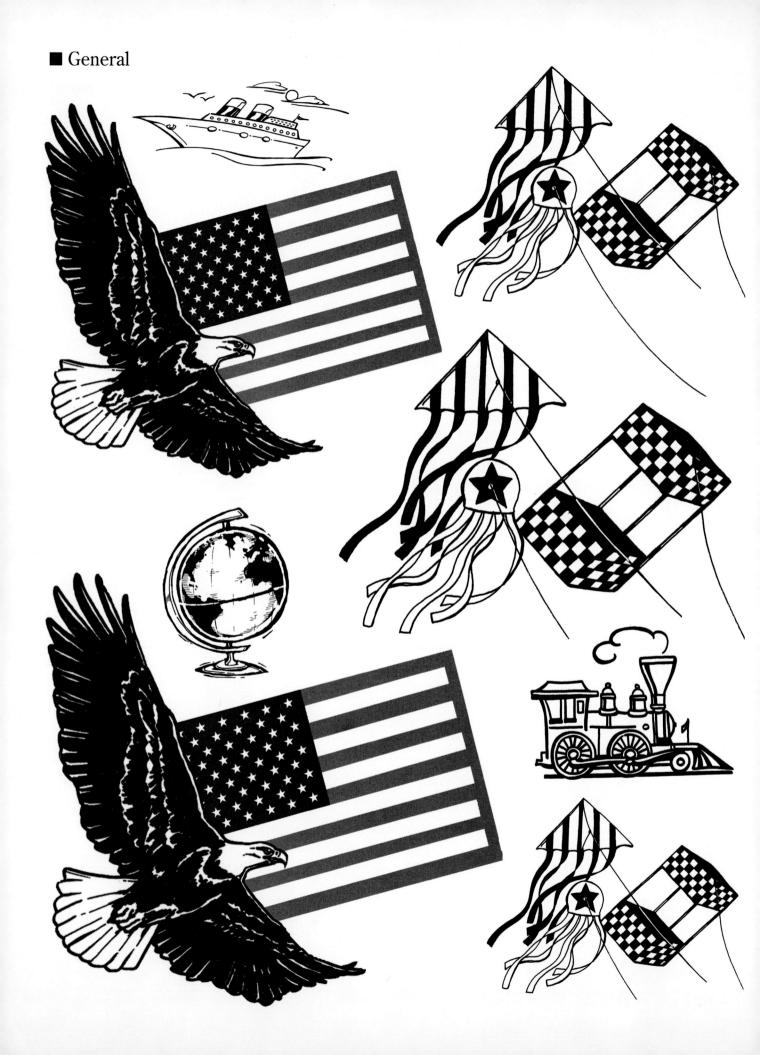

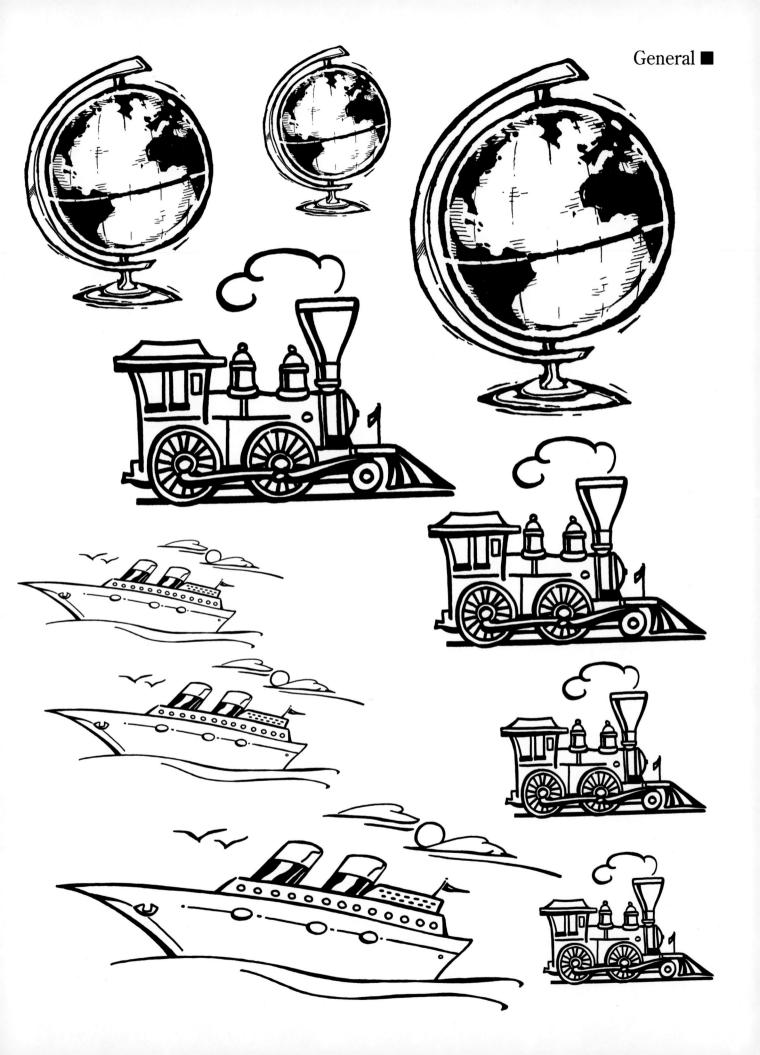

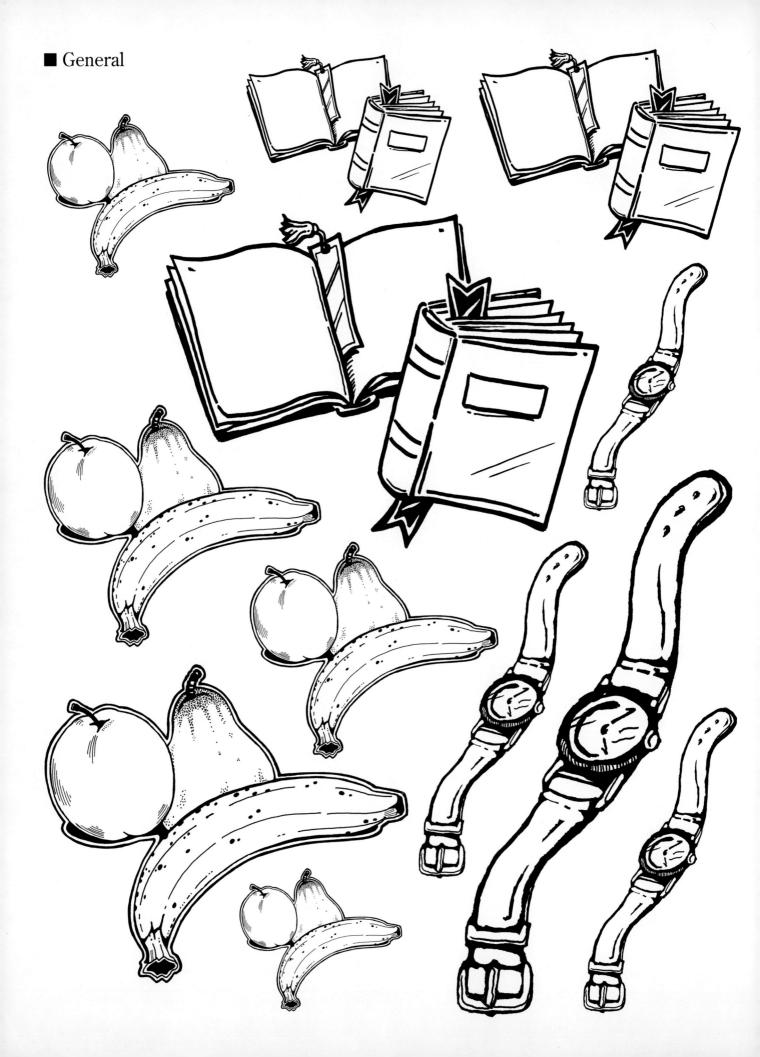

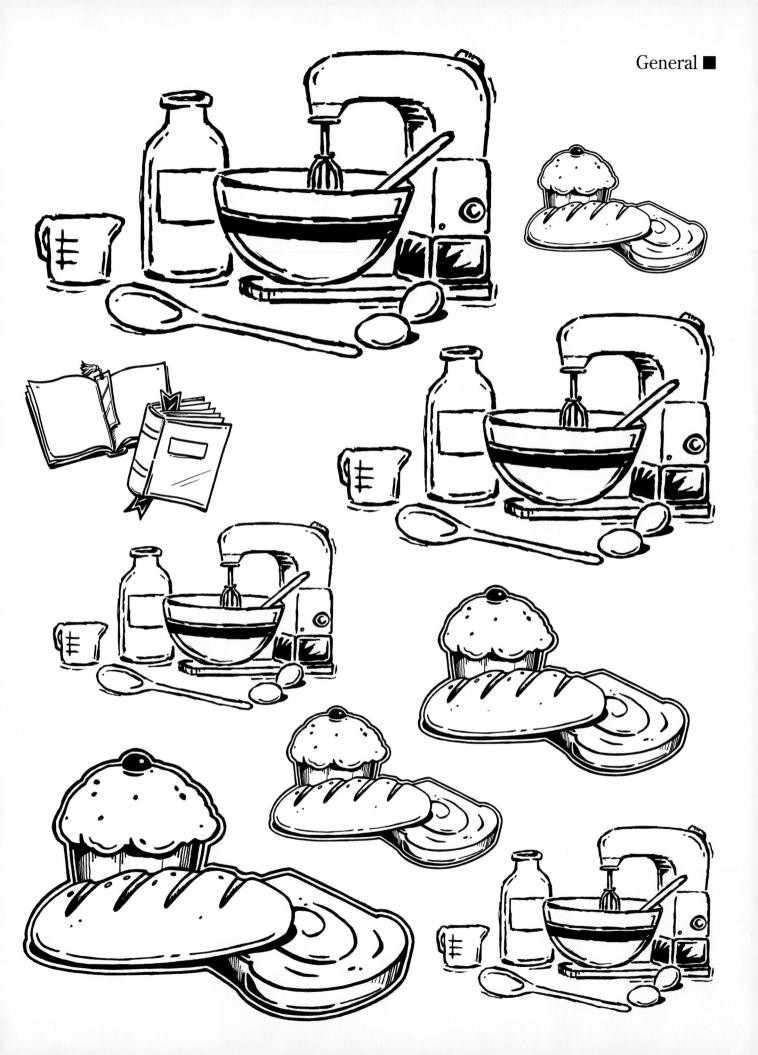

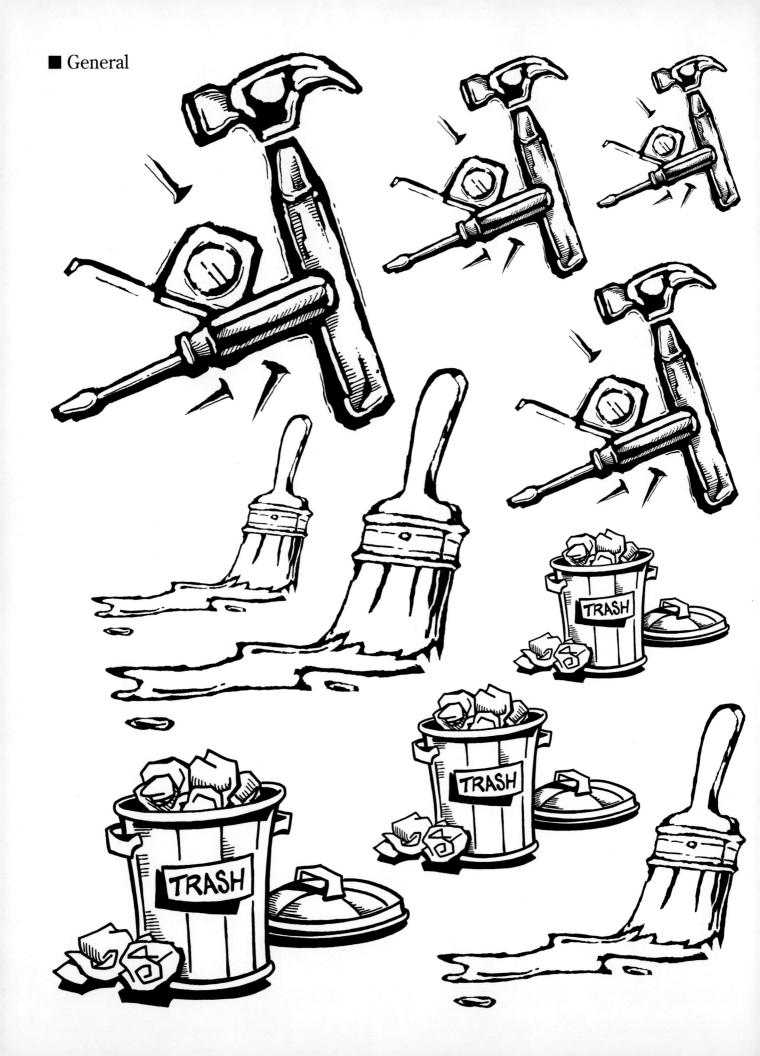